SHARING OU

Published by Holistic Linguistics, Nairn, U.K.

Sharing Our Horizon

*A Journey Through the Scottish Highlands
with Two Adopted Whippets*

Poems and Photographs by
Xenia Tran

CONTENTS

Dedicated to Paul, Eivor and Pearl

SHARING OUR HORIZON

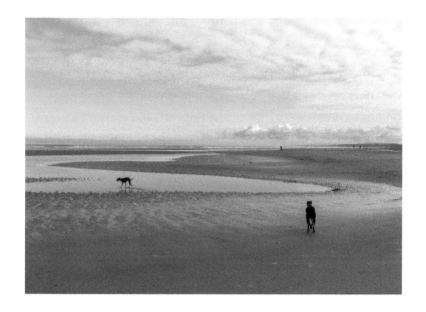

blue sky
can see herself in water
what a blessing
to see both on either side
sharing our horizon

Sixty per cent of net profits from the sale of this book will be shared with animal rehoming charities at the end of each financial year. The charities we donate to will be announced on our blog at www.whippetwisdom.com and via our Twitter feed @WhippetHaiku. We reserve the right to rotate the animal rehoming charities who benefit from our work on an annual basis.

INTRODUCTION

Welcome to *Sharing Our Horizon*, a collection of poems and photographs that capture daily moments in the Scottish Highlands with our two adopted whippets, Eivor and Pearl.

Like most dogs, Eivor and Pearl love spending time in nature. They have taken us to places we had never visited before and the restorative energies of those quiet beaches, mountains and glens have played a big part in their rehabilitation.

The majority of the poems are haiku, haibun and tanka. Traditionally, these poems begin with quiet poetic observation and conclude with a moment of philosophical of spiritual insight. They are written in rhythm with the seasons and the fluctuations of the weather within those seasons.

Readers of our blog frequently comment on the scenery through which we walk, how it relaxes and inspires them. They appreciate the way the dogs look at the world, how they greet every new day with joy.

I recently took part in a writing retreat in which we were invited to write haiku, haibun or tanka every day for thirty days about the light in the world. I realised that this was exactly what I had been doing for the past two years. The poems here are a small selection of those writings.

You are welcome to dip in and out of this collection, to join us on our walks and run with us on the beaches. You are welcome to open a page at random and use it for quiet observation and meditation. However you choose to read this book, we hope you'll enjoy the journey.

With love from Eivor, Pearl and Xenia xxx

THE POEMS

Before the Daffodils

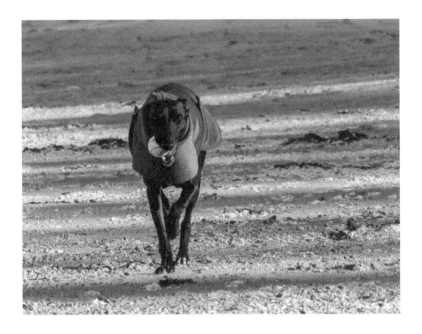

Some friends believe our world began in the wrong house,
locked in a life with people who thought that love alone was
enough. We can see a shadow in their eyes when they realise
our beginnings.

happiness
now is all that matters
the past is cast
our scars fade with time
before the daffodils

That Moment

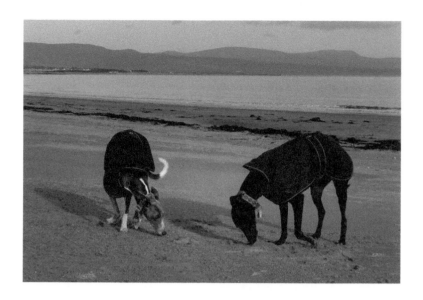

so clear
beneath the sands
your smile
left here by the wind
a loving brother

When Nature Gives Us Poems

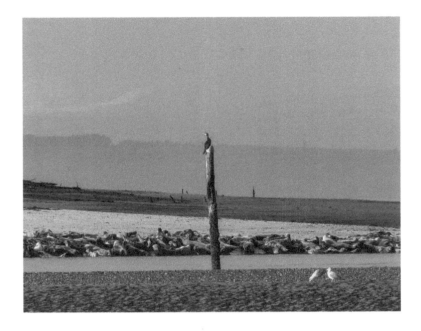

one day of warmth
melts a winter of snow
seals bask in the sun
calling their pups
watched by a cormorant
on a pole in the river
cast your net to
capture the sounds
follow your gaze
feel nature give poetry
in her making

A New Season

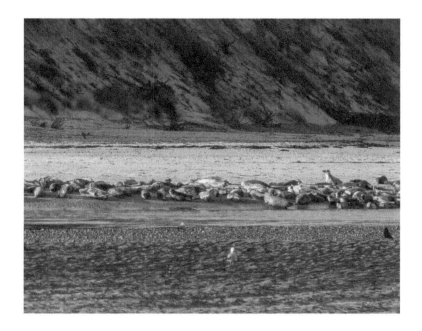

seals surrender
to warmth of the rising sun
leaving spring
to swim in the river
string her pearls in the sea

Spring Me Happy

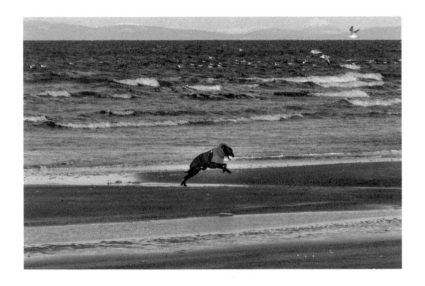

spring me a splash
in the channel
that sparks crystals
from mountain to sea
spring me a dance
on the sands of
the shoreline smiles
flying for all to see
spring me
a reason's season
where every day is
the best it can be

A Glimpse of Spring

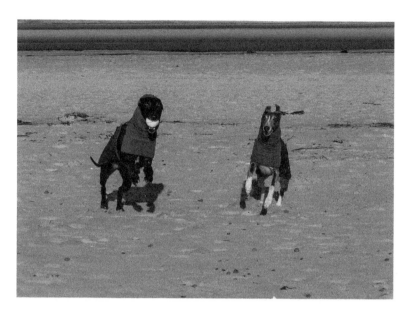

We're enjoying a sunny morning playing ball on the beach. With Siberian winds approaching we know today's weather is a good thing. We catch our rays of sun and run. For the first time in weeks the sand is soft, all the way from dune to shoreline.

<div align="center">

yellow crocus
here and there a purple pause
before the snows

</div>

When Stillness Runs Deep

The eastern wind blows horizontal snows in total silence.
There's something unique about her quietude, the peace she
brings. Airports and railway stations are closed. People are
advised to stay at home. With no traffic, the stillness runs
deep. We close our eyes and breathe.

<div align="center">

meditating
in front of the fire
one garden

</div>

Hazy Moon

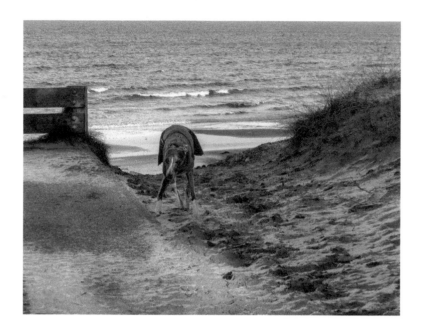

hazy moon
we carry the starfish
back to sea

A Loving Gift

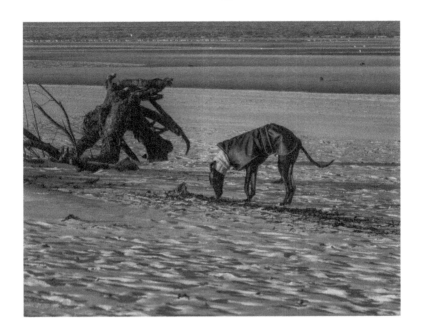

driftwood
when spirit leaves the trees
a loving gift

A New Breath

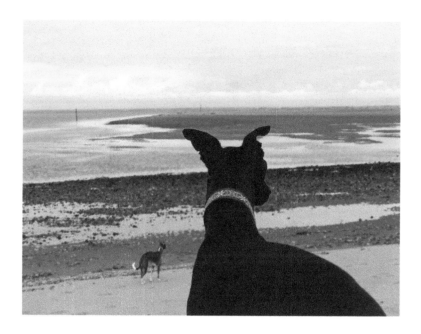

The weather is kind today. It feels good to leave our coats at home, breathe the sea air. Seals are barking on the bars. A deerhound leaps in and out of tidal pools, inviting us to follow.

<div align="center">

misty morning
clouds fade into blue
spring blossoms

</div>

Highland Breeze

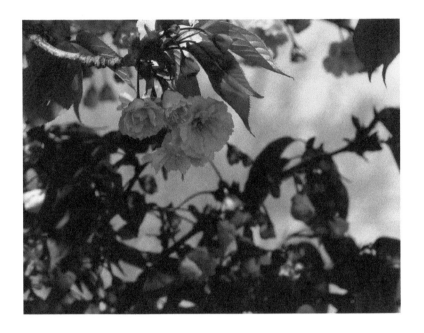

fresh breeze
even in the highlands
cherry blossom

Evanescence (I)

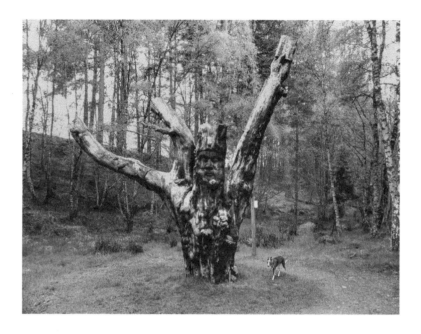

Near the forest of Inshriach lies a trail of sculptures made from
fallen Caledonian pine. Frank Bruce was a self-taught artist
who wanted his art to be accessible to all. The state of decay is
intentional. He wanted his sculptures to return, over the course
of time, to the earth from which they came.

the wind echoes
within a walled garden
thoughtful trees

Evanescence (II)

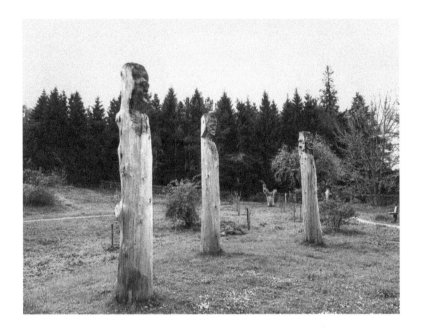

As a child Frank preferred to be outside rather than stuck at
school. He was more interested in the beauty and wisdom of
nature than in books or sums. He has left us a gift that leaves a
lasting impression, even though the lifespan of his art is brief.
In this peaceful natural setting his sculptures ask questions
that are timeless.

<div style="text-align:center">

trees of thought
a trail for meditation
above the river

</div>

Poems in Your Eyes

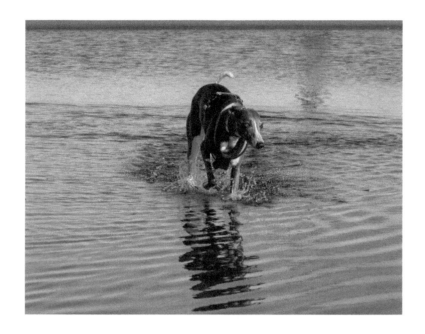

I can read
poems in your eyes
across the water

Dream Waves

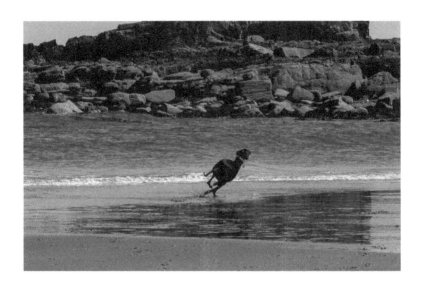

words can barely capture dreams
whose wings caress the dawn
the world has so much beauty still
it wants to show us more
we are here to chase the waves
in shades of turquoise blue
our gratitude spills over
when blessings feel this true

Call of the Wild

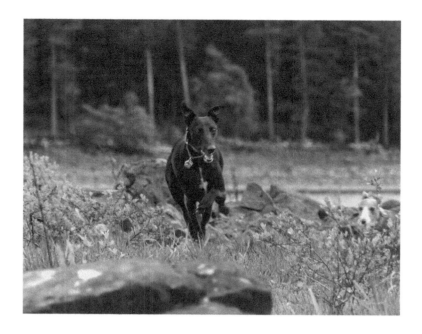

morning dew
silvers summer grass
old instincts follow
where stars have kissed the rocks
a new journey

A New River

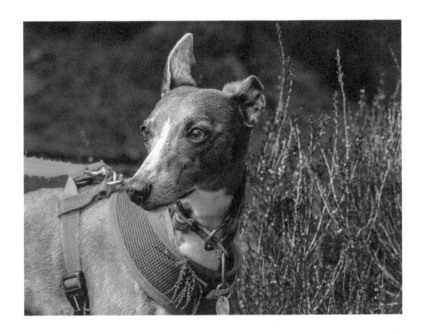

in the field
where dreams wander
a new river

Spring Me Blue

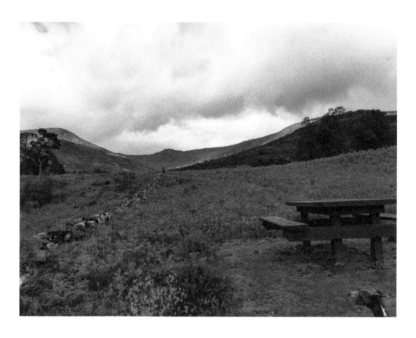

It is colder today, and on the slopes of Creag Meagaidh it's colder still. The season has a different rhythm here, a gentle beauty of her own. The light is bright between the showers. Young leaves shimmer in the breeze, clouds curl above the corrie.

spring follows
her own trail in these mountains
bluebells catch the wind

Mountain Path

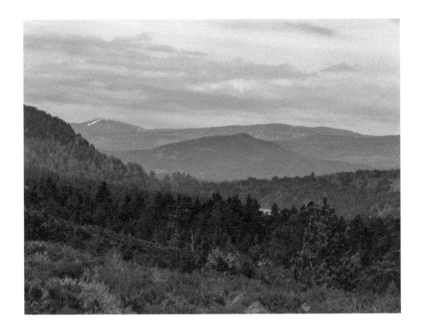

mountain path
climbing through heather and pine
the loch's sparkle

Dancing Leaves

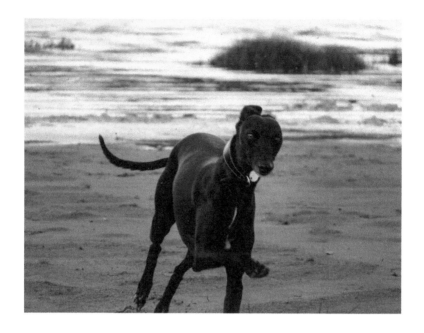

home is where I am
dancing like the leaves
when my spirit soars

A Painting from the Sky

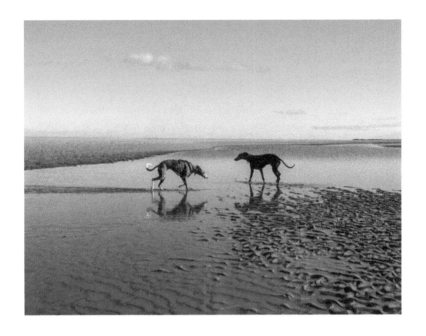

lagoon holds
a painting from the sky
in her arms

Joie de Vivre

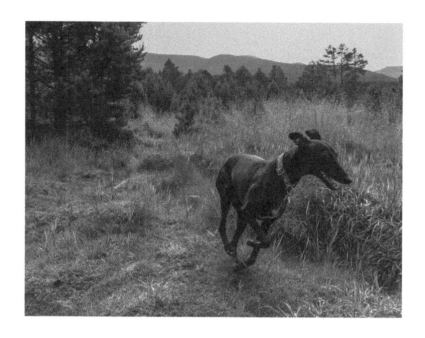

irresistible
this call to explore
blind corners
in the warm heart of the glen
our eyes sparkle with stories

Heart of the Glen

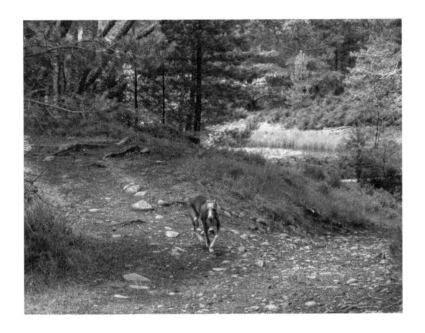

From the moment we arrive in the glen the energy feels different. The walkers we meet have this quiet calm that belongs here. A nod and a smile tell a thousand stories.

The ferns notice each glance before it slips into the trees. It can rest here with all the other peaceful glances left behind. The trees feel every shimmer that rises from the burn and joins the sky. Each paw print and footstep remembers who left it. The grass waves in the breeze while we walk on, wonderstruck.

> such beauty
> following a butterfly
> who knows the way

Moon Blessing

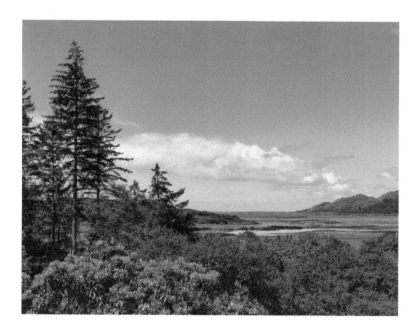

Loch Moidart
the moon leaves her blessing
beyond the flowers

The Silver Cloud

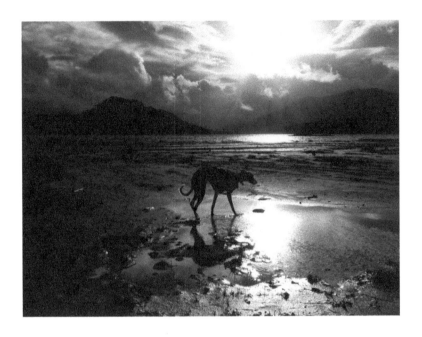

the silver cloud
you step out of
so easily
sees you soon belong
among the pine's
fine melody
the sea is your friend
and you honour the moon's
moves with the tide
as you stride
wide and far along
the shoreline's own
silver lining

Peaceful Waters

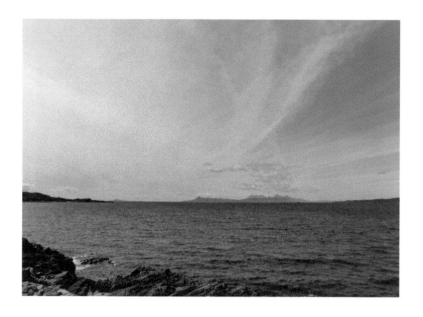

above the islands
white clouds fold in prayer
peaceful waters

Journey in Time (I)

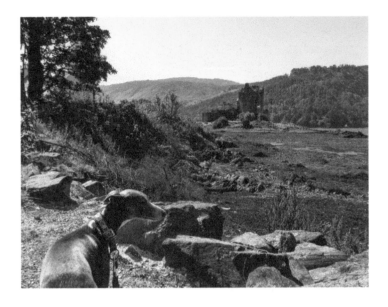

The first time we visited Eilean Donan Castle was more than nine years ago. We travelled north from Cumbria and stopped there on our way to Plockton. It was the first week in August, under a clear blue sky with only one other car in the car park.

A kayak floats over Loch Duich and I walk into the cafe to get some coffee. The terrace overlooking the castle is empty. We sit down at a picnic table when the kayaker comes ashore and gives us a big wave. 'Mind if I join you?' he asks. One of the students on a Summer job in the cafe soon joins us too and brings a few pieces of cake. 'Everyone you meet here is so interesting!' he says. Full of youth and dreams, he tells us he is excited about the life in front of him. Full of years and dreams, I realise that I am excited about the life in front of us too.

one by one
birds land around the table
eyes twinkle

Journey in Time (II)

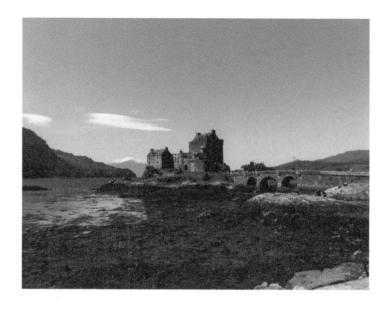

Eilean Donan is a lot nearer now and we stop here on our way to Plockton. It's the first week in August and under a clear blue sky the car park is full.

A cheery attendant suggests we park on the other side of the bridge and come back on foot. The view of the castle from the other side is stunning. There are hundreds of people who have flown in from all corners of the world to see this place. We hear excited voices in different languages. An American woman walks over and asks if she can stroke Eivor and Pearl. 'I had to leave my dogs at home and I miss them so much,' she says. As she crouches down among the crowds Eivor and Pearl look into her eyes and give her all the time she needs.

> time to pause
> all of us on a journey
> gathered here

Tidal Eclipse

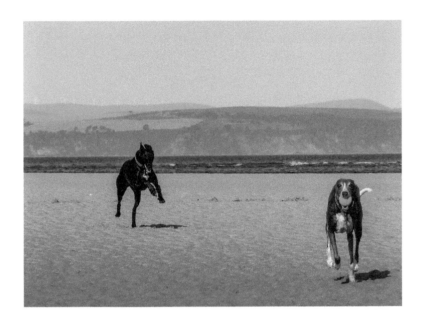

morning and evening
the sea leaves an empty beach
our tidal playground

Changing Seasons

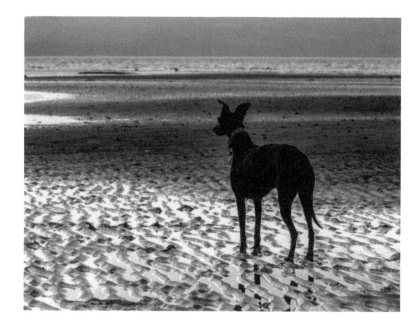

We're in our fifties but are still referred to as 'the young couple'
by our neighbours. It sometimes feels as if they forget that
when they grow older, we grow older too. The moon harvests
a few more souls each August. As I walk these streets in silence
I remember the banter over garden gates, the smiles waving
me in for a cup of tea and stories about how life used to be.

> when days cool down
> sky unfolds her warmest
> blanket of colours

Komorebi

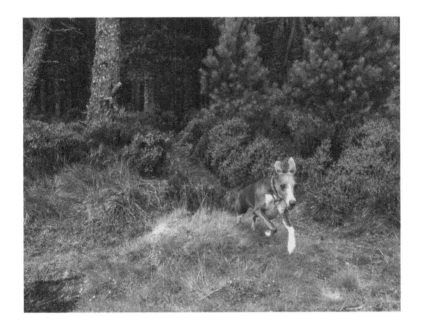

The smells of soil grow richer and deeper as the seasons change.
The earth feels full of life beneath our feet, the roots of trees.
The sun is lower in the sky and her tones are warming.
Nurturing and sharing in the dappled forest light, the pine
trees redirect their crowns. The Japanese have a special word
for this beautiful play of rays between the branches: *komorebi*.

bees dazzle
around the purple heather
autumn wind

September Green

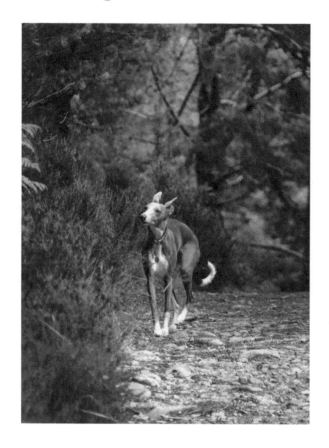

a green breath
still curls its way
along the trail
when rains begin to lift
a sweetness of pine

Sapphire Blue

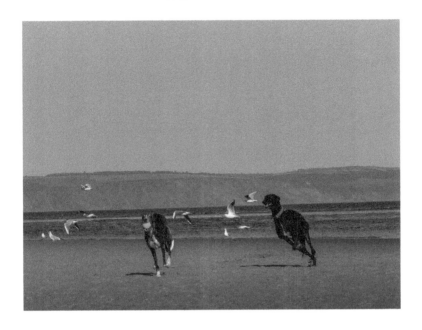

sapphire blue
September's waters
sparkle with joy

Magic Light

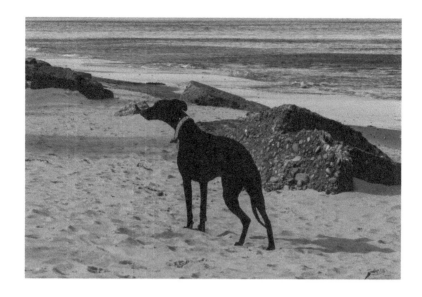

the sun takes longer
to rise above dune and pine
along our shores
magic light of morning
dreams and wakes the sky

Silence

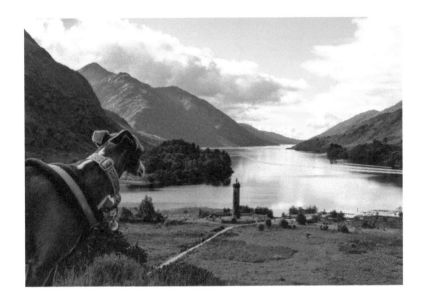

silence
a deep lake
of quietude

A Fairy Tale

the winds blow wild and
free in the forest
sheltered by trees
a soft pulse beats
in the soil
fairies sweep the leaves
and wash the curtains
fearless of the wolves
that prowl and leap
into the joy
of their own autumn

Writing the Stones

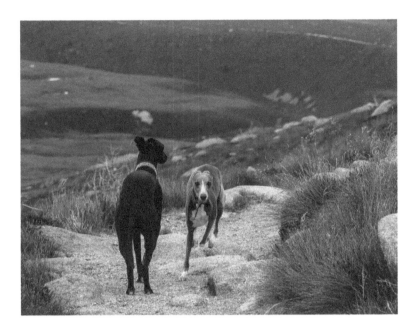

The shelter was a grey place where seasons barely changed. The sunlight came from loving people who found hearts to give us homes. We turned towards their light and that is what sustained us. We see this light today in others too, in every butterfly and flower. It is this light that warms our faces in the wind. It is reflected in the wisdom of the stones. It is this light that binds the pack we walk with. We dip our pen in gratitude and love. We write to share the light that saved us.

grass turns gold
memories of summer
dance on the trail

Stairs of Nature

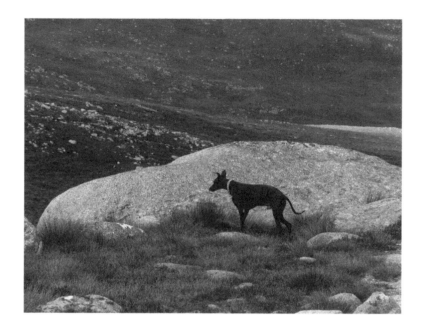

these steps
between shade and sunlight
make the difference
how warm we will feel
how far we can see

Shifting Sands (I)

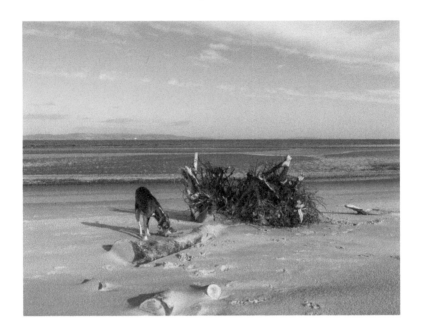

There is new driftwood on the beach. Carried off by the river and abandoned by the sea, their roots now face the sky. The smells of forests and hills have followed. Sometimes, in the distance, we hear a chainsaw: someone cutting off the bigger branches. There's enough time for the wood to dry and keep us warm in winter.

above the waves
the call of whooper swans
October wind

Shifting Sands (II)

The beach is quiet today. The sun feels warm now the wind
has gone and it is good to close our eyes and hear the waves.
Gulls preen their feathers while they wait for the tide to turn.
We open our eyes and exhale. After the rains in the west it is
a relief to walk and breathe the sea air.

<div align="center">

wet sand stays
where soft sand blows
an autumn leaf

</div>

A Glimpse of New Tomorrows

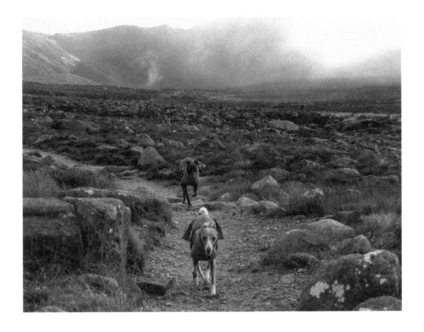

the sun is ready
to break through
kick-start the dazzle
of mountain dew
while we touch
the clouds we
feel the breath
of winter
she will be here
to rest her snows
cover these russets
while folding golds
dreaming the world
with new tomorrows

Transformation

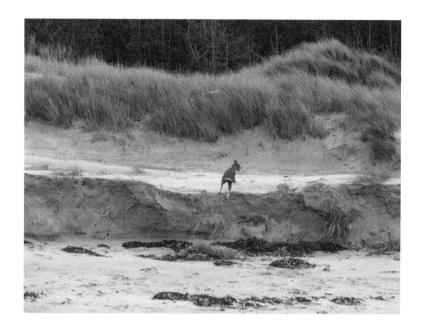

after the storm
the beach transforms
a big leap
will take us to the forest
the sound of temple bells

A Peak into Winter

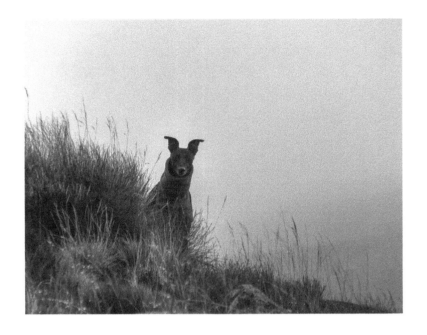

this new dawn
a gate between the seasons
opens further still

Autumn's Voice

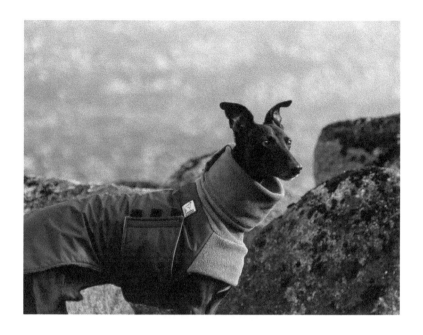

it's good
to rest and be warm
on the inside
when autumn talks of leaving
clouds hand gifts of snow

First Snow

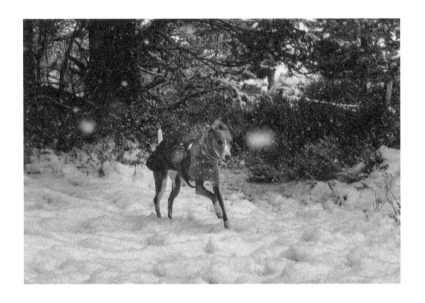

walking on stars
nature lights the way
through winter

Acceptance

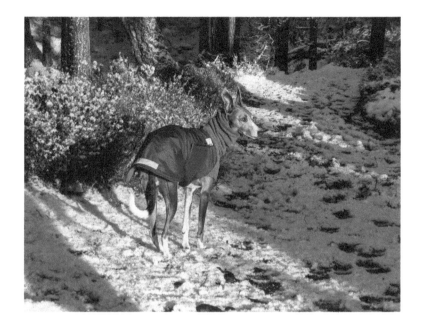

in dappled light
winter comes of age
snow deepens
her laughter lines in branches
her spirit in your eyes

Where Frogs Are Sleeping

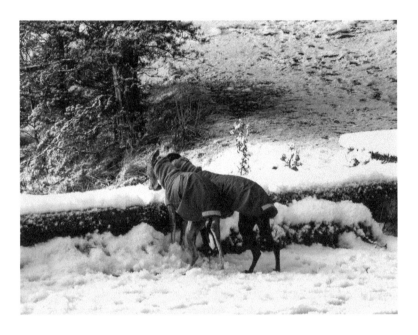

In the glen November rain has turned to snow and blankets our
trails with starlight. Most trees have lost their leaves. A delicate
filigree stands guard beside the ice that sheets the loch. The
world turns almost monochrome with subtle hints of colour.

sleeping frogs
their hearts beat below the ice
bliss, bliss

Low Sun in Bent Grass

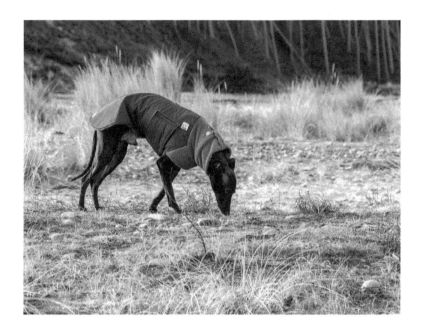

when snow gates close
we return to the coast
low sun in bent grass
glances back for one more chance
to dance with the mountains

Winter Solstice

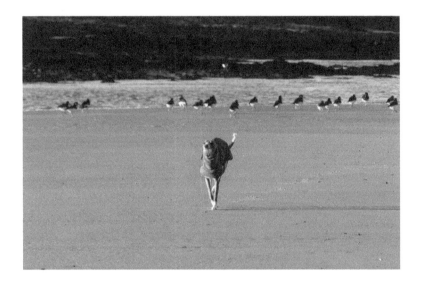

On this shortest day the light is extra warming. Oystercatchers
stride out along the shoreline. We run and chase some balls,
grateful for the blue sky and the warmth of winter.

so peaceful
every blink a golden hour
on solstice day

Warm Path Through Winter

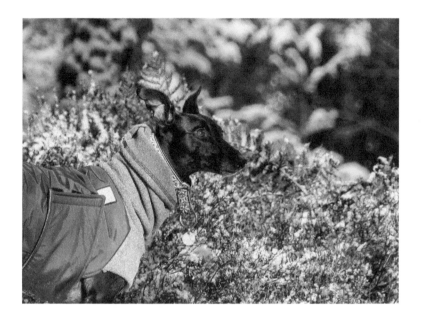

a warm path
weaves her way through winter
from eye to heart
soft glow of the low sun
blows a silent kiss

Song of Life

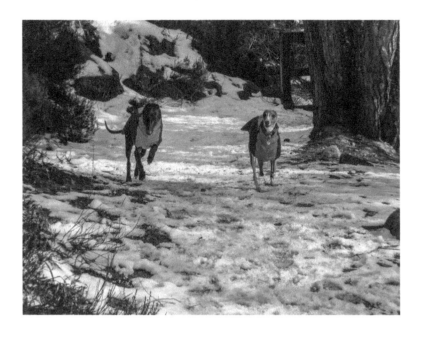

song of life
leaning into the wind
your smile

Bothy Tales

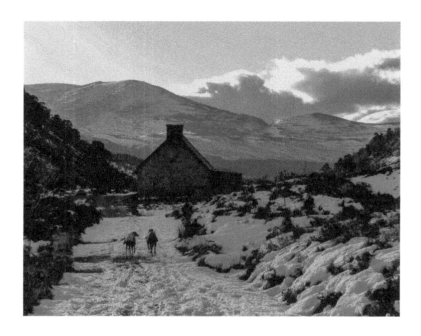

fresh snow underfoot
the colours of loch and sky
so soothing on the eye
to the sound of distant capercaillie
the bothy at Ryvoan Pass
offers shelter among mountains
for all who love those special
places where wanderers' tales
curl around a fire

Winter Morning

The half-moon fades away in a daze of blue. The air is crisp.
Gulls squawk and peck at mussels and clams. The beach smells
of seaweed and driftwood, the crabs that walked here. It is time
to play.

> winter rings
> her wings of ice and snow
> around the sun

When Old Becomes New

seagulls rest
on sandbars
warming feathers
in winter sun
while we fly
to catch each ball
and shimmy down
the shoreline
it is so peaceful
to play old games
with new eyes
with every leap
the mountains
speak of wonder
after the wolf moon

True Friends

true friends
dance together in the snow
with love so deep
beyond the moon and stars
beyond the season's reasons

Frozen Footsteps

Last week's footsteps look fresh on the frozen path where
our paws leave no mark. The warm glow of the morning sun
welcomes us like long lost friends and in this silence I feel
like coming home. Coming home to all that is well in the world,
to all the magic that nature has to offer and to the simple ways
in which the sparkling frost on the trees connects us to the
magic within ourselves.

<div style="text-align:center">

frost rests
in the silent caress
of dawn

</div>

Song for a New Day

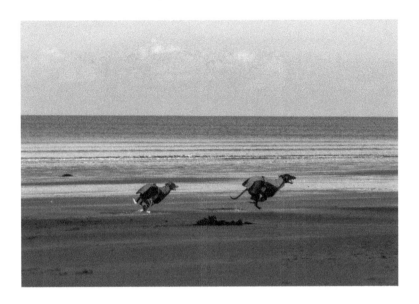

The sun rises over the dunes and the night's frost evaporates with every step along the soft sand. Sea and sky treat our eyes to pale blues and indigos. A third eye opens and sees beyond the horizon of this morning's dream. Our intuition is here to guide us through the day. We hear her voice in the seagull's call, the soothing movement of the sea.

light lifts and folds
in rhythm with the waves
song for a new day

Freedom of the Dawn

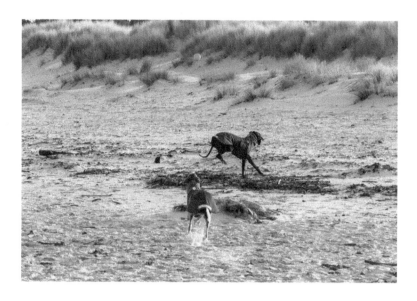

Dawn opens her door and pours her warmth on weathered sands. We are free to bounce and pounce, catch balls that spin and fly towards the sky with all her colours.

<div align="center">

frost melts
the Buddha in our garden
smiles again

</div>

Divine Timing

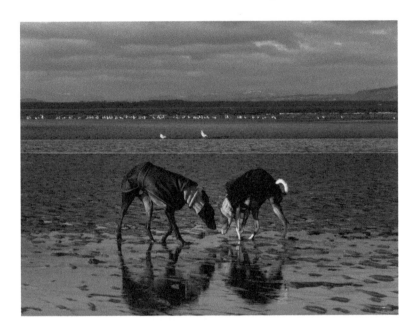

The snows are melting into rivers. Behind the mountains, spring prepares her blessing. Gulls are waiting in the sun for the tide to turn. They trust the sea. We trust the moon. She understands where peace is needed and leaves a perfect blue behind the clouds.

what the water knows
in life, divine timing
always flows

ABOUT THE POETRY FORMS

HAIKU

Haiku is a Japanese poetry form that evolved during the seventeenth century from previously existing Chinese and Japanese forms of Zen poetry. Matsuo Bashō (1644–1694) is one of the best-known haiku poets of that era and his work has been translated and interpreted by scholars around the world.

For early practitioners, haiku was seen as a way of life. To write a haiku, or to read one, is a reminder of the impermanence of all that we experience on our journey. They are almost always written in the present tense, and seek to capture fleeting moments in the seasons of nature and the seasons of our own lives. There is often a spontaneity, a wide-eyed way of looking at something that is captured with humility, using simple language.

Japanese haiku contain a seasonal word or *kigo*, a word that indicates the time of year in which the haiku takes place. The haiku is made up of seventeen sound-units or *on*, with five in the first line, seven in the second line and five in the third line.

As the popularity of haiku spread around the world, these sound units were equated to syllables, though in fact they are not the same. The restriction of using seventeen syllables spread over three lines in English haiku led to some adding words or syllables to make up the required count, which gave a stilted feel to the poems. Today, this practice of syllable-counting is no longer promoted by the majority of contemporary haiku poets and haiku organisations.

Bashō's haiku evolved over his lifetime, and the same is true of two of his famous successors, Yosa Busson (1716–1784) and Kobayasho Issa (1763–1828). For all three, the later work is quite different to the early writing. In this sense haiku is also about capturing change: each poem distils the essence of a moment, but over the course of a lifetime's work, the sum total of those moments reveals a story of personal growth.

Throughout the ages, the rules for composing haiku have been revised many times. One of the rules that is still adhered to among some of today's poets is that a haiku is divided in a fragment and a phrase. The fragment can either be the first or the third line. For example:

full of blossom
the song of a blackbird
echoes the wind

Here 'full of blossom' is the fragment and 'the song of a blackbird echoes the wind' is the phrase. But in the haiku below it is the other way around: 'chirping between tree buds' is the phrase and 'a blue sky' is the fragment.

chirping
between tree buds
a blue sky

Japanese writers use words of punctuation or 'cutting words' (*kireji*), which in Western haiku are often translated with punctuation marks, though they are not the same thing. Jane Reichhold believed that in English haiku, syntax can be used to express the necessary breaks without the need for punctuation.

Like the traditional haiku poets, I would describe haiku as a way of life, a way to look and marvel at nature and see the magic in the ordinary. To me, this is very much in the spirit of how Eivor and Pearl look at the joys in the everyday and the beauty in nature. Haiku gives us an opportunity to capture these moments in a few words so that others can experience a glimpse of what we see and connect it to their own experience.

TANKA

Tanka poetry originates from Japan's imperial courts and was frequently written by women. It contains thirty-one sound units spread over five lines. The first seventeen sound units are spread over the first three lines (as in haiku) and many of the same rules apply. Whereas haiku are written in the present tense, tanka can switch between tenses and voices, using the third line as the pivot line in which the poem shifts in mood or subject. The pivot line also allows the poem to switch between reality and fantasy, between memories and dreams for the future or simply between one location and another.

Tanka were used as correspondence between lovers and friends, and to mark celebrations such as births and weddings. Poets also wrote tanka as a way to bring expressive emotion into a poem, something the haiku form at the time did not allow.

HAIBUN

Like haiku, haibun originated in seventeenth-century Japan, and was first developed by Bashō in his travel journals.

A haibun consists of one or more paragraphs of prose, such as a passage from a letter or journal, followed by a haiku or tanka. The poem part of the haibun is used to bring a different voice or dimension to the piece and can be an effective way of telling two stories at once. A third dimension can be added to a haibun in the form of calligraphy or a photograph. Some poets refer to a haibun containing a tanka as 'tanka prose'.

Bashō's best-known haibun come from a work called *The Narrow Road to the Deep North* (translation by Nobuyuki Yuasa), also known as *Narrow Road to the Interior* (translation by Sam Hamill) or *Journey to the Interior* (translation by Jane Reichhold).

The journey through the landscape recorded in haibun can refer to the outer landscape of nature as well our inner personal landscape.

I give all my haiku, tanka and haibun a title for ease of reference, though traditionally they are untitled.

FREE VERSE

Among the haiku, tanka and haibun I have included a number of free-verse poems consisting of forty-four words or less.

ACKNOWLEDGEMENTS

The poem 'A Warm Heart in Winter' previously featured on Carpe Diem Haiku Kai as the winner of Carpe Diem's Tanka Kukai One: Winter Love.

'Frozen Footsteps' has previously been published in the anthology *Chiaroscuro – Darkness and Light*, edited by Mary Grace Guevara and Björn Rudberg (dVerse Poets, 2017).

'A Loving Gift', 'Poems in Your Eyes' and 'Divine Timing' have previously been published in the anthology *All My Years – A Tribute to Jane Reichhold*, edited by Chèvrefeuille (Chèvrefeuille's Publications, the Netherlands, 2017).

I am very grateful to Mary Grace, Björn and Chèvrefeuille for featuring my work in this way.

This book owes much to many. The team at Reedsy for their editorial support; John Hubbard for his creative visions for the cover and internal design; Emergents and XPO North Writing and Publishing, who kindly offered me a place on their 'DIY Self-Publishing – A Beginner's Guide' online course; my fellow photographers and poets in the blogosphere for their inspiration and encouragement: the prompters at the WordPress Weekly Photo Challenge; the team serving poetry and virtual drinks at dVerse Poets Pub; Chèvrefeuille (Kristjaan Panneman) at Carpe Diem Haiku Kai; Frank J. Tassone at his Haijin in Action Blog; Ronovan Hester at Ronovan Writes; Frank Jansen at Dutch Goes the Photo and several others who provided regular prompts for linking images and words. I am deeply grateful to the followers of my blogs Whippet Wisdom and Tranature who take the time to visit and comment. Your input is much appreciated and your encouragement to publish has been the guiding force behind this book.

A big thank you to all the teachers and fellow poets who have guided and inspired me along the writing path: Matsuo Basho, Kobayashi Issa and Jane Reichhold through their inspiring body of work; Janni Howker and the women at the Women's Writing Group at the Brewery Arts Centre in Kendal; the Wordsworth Poets during our Tuesdays at the Wordsworth Trust in Grasmere; and Cynthia Fuller for her input and guidance at University of Newcastle during my post-grad studies.

Special thanks to Ciaran Carson for his beautiful workshop on writing haiku, to Gerald Dawe for helping us see where poems come from, to Glenn Patterson's invitation to write about the first thing that catches our eye and to Sinéad Morrissey for helping us to look at landscape as a mirror. The wisdom they shared during an inspiring Summer School at the Seamus Heaney Centre for Poetry at Queen's University Belfast will always stay with me.

Last but not least, my everlasting thanks to Paul, Eivor and Pearl, the best fellow adventurers through this life I could ever have wished for.

ABOUT THE AUTHOR

Xenia Tran was born in the Netherlands in 1962 and began writing and journaling at a young age. She enjoyed reading poetry in Dutch, French and English and soon English became her language of choice for writing poetry and short stories.

Her early studies were interrupted by a desire to travel and explore different cultures. It wasn't until she was happily married and settled in London that she decided to return to study as a mature student.

She studied for degrees in French Studies and in Applied Linguistics at Birkbeck College, University of London, whilst working full-time as an administrator in a research centre for a French company and running her own holistic practice as a complementary therapist.

When she and her husband relocated to Kendal to be closer to her husband's ageing mother she joined a women's writing group where her passion for creative writing reignited. She submitted a few poems to publications and websites and was delighted to see them accepted. She wrote short stories and poems about their adopted rescue dogs with the idea of creating a book to help raise funds for animal shelters.

She worked as a volunteer in a local animal shelter and later did voluntary work for a foster-based rescue organisation.

After attending a Summer School at Queen's University Belfast she enrolled at Newcastle University, where she completed a postgraduate course in Creative Writing before relocating to the Scottish Highlands.

The beauty of the Highland landscape and the quality of its light inspired her to invest in a good camera and take photographs to accompany her writing for her blog Whippet

Wisdom. It was meant to be a simple place to record the walks with their adopted dogs in images and words, an organic place to develop her writing and photography. It quickly gained a loyal following, she met and connected with poets, fiction writers and photographers around the world, and in 2018 she started a second blog, Tranature, to share her personal observations on nature.

BIBLIOGRAPHY

Aitken, R, *A Zen Wave – Basho's Haiku & Zen* (New York: Weatherhill Inc, 1995).

Aitken, R, *The River of Heaven – The Haiku of Bashō, Buson, Issa and Shiki* (Berkeley CA: Counterpoint Press, 2011).

Boa Nyx, I, *Small Clouds – In Memory of Jane Reichhold 1937–2016* (astrologyreboot.com, 2016).

Bowers, F, *The Classic Tradition of Haiku – an Anthology* (Mineola NY: Dover Publications Inc, 1996).

Brickley, C, *Earthshine* (Ormskirk: Snapshot Press, 2017).

Carson, C, *Belfast Confetti, Oldcastle Co Meath* (The Gallery Press, 1989).

Hamill, S (trans), *Matsuo Bashō – Narrow Road to the Interior and Other Writings* (Boston MA: Shambhala Publications Inc, 1998).

Hamill, S (trans), *The Spring of My Life – Kobayashi Issa* (Boston MA: Shambhala Publications Inc, 1997).

Klinge, G, *Day into Night – A Haiku Journey* (Rutland VT: Charles E Tuttle Co Inc, 1980).

Landis Barnhill, D (trans), *Bashō's Haiku* (Albany NY: State University of New York Press, 2004).

Lanoue, D G (trans), *Issa – Cup of Tea Poems, Selected Haiku of Kobayashi Issa* (Berkeley CA: Asian Humanities Press, 1991).

Lanoue, D G (trans), *Issa's Best: A Translator's Selection of Master Haiku by Kobayashi Issa* (New Orleans LA: HaikuGuy.com, 2012).

Lanoue, D G, *Pure Land Haiku: The Art of Priest Issa* (New Orleans LA: HaikuGuy.com, 2013).

Reichhold, J, *A Gift of Tanka* (Gualala CA: AHA Books, 1990).

Reichhold, J, *Writing and Enjoying Haiku* (New York: Kodansha USA Inc, 2002).

Reichhold, J (trans), *Bashō – The Complete Haiku* (New York: Kodansha USA Inc, 2008).

Reichhold, J, *A Dictionary of Haiku* (Gualala CA: AHA Books, 2013).

Stevens, J (trans), *One Robe, One Bowl – The Zen Poetry of Ryokan* (Boston MA: Weatherhill, 2005).

Ueda, M, *Bashō and his Interpreters* (Stanford, CA: Stanford University Press, 1992).

Van den Heuvel, C (ed), *The Haiku Anthology* (New York: W W Norton & Company Inc, 2000).

Wakan, N, *Haiku – One Breath Poetry* (Torrance CA: Heian International Inc, 1993).

Wakan, N B, *The Way of Tanka* (Brunswick, Maine: Shanti Arts LLC, 2017).

Yuasa, N (trans), *Bashō – The Narrow Road to the Deep North and other Travel Sketches* (London: Penguin Books Ltd, 1966).

STAY IN TOUCH

You can stay up to date with Eivor and Pearl's story
by following our blog at:
www.whippetwisdom.com

and by following us on Twitter:
@WhippetHaiku

If you're interested in following our nature blog,
you can also find us at:
www.tranature.com

and by following us on Twitter:
@tranature18

We look forward to seeing you there!

Lightning Source UK Ltd.
Milton Keynes UK
UKHW020629160321
380429UK00007B/62